Clients and

Designers

Dialogues with

CEOs and managers

who have been

responsible

for some of the

decade's most

successful design

and marketing

communications.

Ellen Shapiro

Watson-Guptill

Publications

New York

First published in 1989 by Watson-Guptill Publications,
a division of Billboard Publications, Inc.,
1515 Broadway, New York, N.Y. 10036

Library of Congress Cataloging-in-Publication Data

Shapiro, Ellen, 1948–
 Clients and designers : dialogues with CEOs and managers who
have been responsible for some of the decade's most successful
design and marketing communications / written and designed by
Ellen Shapiro.
 p. cm.
 Includes index.
 ISBN 0-8230-0639-5
 1. Design services—United States—Marketing.
2. Communication in design. I. Title.
NK1403.S53 1989 89-14640
745.4′068—dc20 CIP

Distributed in the United Kingdom by Phaidon Press Ltd.,
Littlegate House, St. Ebbe's St., Oxford

Manufactured in Singapore

First printing, 1989

1 2 3 4 5 6 7 8 9 10/95 94 93 92 91 90 89

Contents

Preface

For every kind of business and institution, design is becoming an essential strategic resource. From top management of large corporations to owners of small businesses, establishing successful relationships with designers is increasingly important.

Each year, more and more organizations will need to create an image, publish an annual report, recruit employees, open a showroom, launch a new product, advertise a service, educate the public . . . and achieve a range of other marketing and communications objectives. How should they go about it?

This book attempts to answer that question through dialogues with CEOs and managers who have been responsible for some of the most successful design and marketing communications programs of the decade; innovators who have experienced firsthand the success that good design has brought to their businesses. *Clients and Designers* has been structured to follow the typical phases of the client/designer relationship, from exploratory phone calls through evaluating the finished work.

To begin, *"Introductions and Approaches"* discusses how smart clients go about finding the right designer or firm to assist them. What is the best way to ascertain capability, conduct telephone interviews, and handle the cold calls and mailings that come in? How can clients judge whether a particular individual or firm would be a good "fit"?

In *"Presentations and Proposals,"* the key things that savvy clients look for when they meet with designers are emphasized. Is there a protocol for productive portfolio reviews? What about requesting and evaluating proposals and entering into contractual relationships? Is asking for "work on spec" ever acceptable? Is it wise to get started without a formal agreement or proposal?

The next part, *"Working Relationships that Work,"* focuses on the collaborative efforts of various projects. How do some of the most successful clients and designers across the country set project objectives? How much direction and control should a client, ideally, exercise?

What are a client's responsibilities? How have clients in diverse industries managed design firm relationships that have increased their company's growth and profitability?

Finally, in *"Results, Rewards, and the Future,"* the interviews answer questions such as, how can good design benefit all kinds of businesses and industries? When is risk-taking appropriate? And how should work be judged? Is performance in the marketplace the only standard? Or are other factors like winning design awards and simply being pleased also of importance?

Clients everywhere who have been responsible for outstanding work have devised their own answers to these questions; their own philosophies and practical strategies. Twenty-two of them have graciously allowed me to interview them, to explore in some depth their perspectives on the process of design. Their answers are usually logical and sensible, sometimes brilliant, and always interesting.

You will see, though, that even the "best" clients say that it can be frustrating for them to deal with practitioners in the very new profession of design. Clients sometimes find the large design firms intimidating, the medium-sized firms too much alike to differentiate, and the free-lancers "flaky" or "goofy." They sometimes feel that designers aren't in touch with the needs of their departments, their organizations, and themselves as individuals. Kathleen Zann of James River Corporation puts it this way, "Some designers just go off and design whatever they think looks beautiful with no regard for my objectives. They don't listen." John Dietsch of Booz-Allen concurs, "Designers can get on to something in terms of a particular effect, and when it has no relation to the needs of your business, that can be kind of hard to take."

This book is, in part, an attempt to convene a meeting of the minds. It attempts to help set standards; ideal standards based on some of the most successful client/designer relationships that have evolved over the last ten years. It is not, however, a "how-to" book. It can't be. As the dialogues clearly show, client attitudes are often controversial and contradictory. That makes for an equally perplexing set of concerns for designers. If

clients are diverse individuals with contradictory needs and objectives, then, how can designers develop marketing strategies? How can they decide how to structure *their* businesses?

"The purpose of a business is to create a customer," wrote Peter F. Drucker in *Management: Tasks, Responsibilities, Practices.* "The customer is a foundation of a business and keeps it in existence. He alone gives employment. True marketing starts out the way Sears starts out, with the customer, his realities, his needs, his values. It does not ask, 'What do you want to sell?' It asks, 'What does the consumer want to buy?' It does not say 'This is what our product or service does.' It says, 'These are the satisfactions the customer looks for, values, and needs.' "

Designers have traditionally presented what *they* have to offer, a portfolio. Then they waited for a client to be attracted, to buy. Today—because the environment is so much more competitive—designers have to take a much closer look at what clients look for, value, and need.

But buyers of design services are not like customers for Sears' lawn mowers. They have different ideas about what is right, and what they want. Rolf Fehlbaum of Vitra International values "an authentic expression of what is going on now." He could not be more different from Big Eight accounting firm marketing director Robert Moulthrop, who "needs something that accountants will understand." The philosophies and working styles of both of these clients are as different as their aesthetic needs.

"The aim of true marketing," says Drucker, "is to know and understand the customer so well that the product or service fits him and sells itself."

In this diverse marketplace, can this be accomplished?

The answer can be "yes," I think, if three things take place. *First,* if clients, as a whole, regard designers with the same professional respect they regard other

consultants, such as attorneys and management consultants. All clients must extend the same professional courtesies to designers. They would never, for example, ask various attorneys to prepare a sample defense "on spec" to see which one they like before hiring a law firm. Much work and continuous dialogue is needed to end some of the exploitative practices that go on; practices that have caused some wariness on both sides. For example, designers sometimes feel like they're treated as commodities or vendors. They resent clients who demand elaborate proposals, then don't even call back to acknowledge the effort. They are discouraged when their best work is rejected or changed around. They wish everyone were playing by the same rules.

Second, the service can fit the customer and sell itself if nothing on the business side of the relationship is taken for granted. Because there are such large differences among clients—even clients that one design firm might have on its list—on issues ranging from whether overtime should be included in the fee to who is responsible for a printing error, no designer and client should enter into a business relationship without discussing all the creative and financial expectations, in detail, beforehand. To plunge into a project without such an agreement is courting disaster, no matter how great the creative potential.

Third, it can happen if designers recognize that marketing is a long-term proposition, one that must be relationship-oriented and must be directed to the needs and values of specific organizations and individuals. These days, you cannot send out a mass mailing and wait for the phone to ring!

True marketing in the design profession takes place throughout an entire relationship. It starts with visibility. There are many ways clients learn who is out there, doing what. Each designer will have to look carefully at the kinds of projects he or she wants to do, for which organizations, and make the wisest choices from the options: cold calling, public relations, sending out samples, and so forth. And true marketing does not stop when a proposal is accepted or a contract is signed. It is a continuum that begins when an initial introduction is made, and it extends through every phase of the relationship. Only through "creating the customer" in this sense can a creative professional build the kind of loyalty that will lead to future work with that client and possible referrals to the client's colleagues and peers. Because, as you will see, no matter what marketing and sales techniques are employed by design firms, referrals are still the number one source of new business.

Loyalty is a key thread running through these dialogues. You will read of it again and again: "Next time I won't have to go shopping for a designer." "He meets my needs." "I'm certainly indebted to the designers who've made me look good, and I've returned the favor by being loyal to them."

To quote Jonas Klein, a design manager at IBM for seventeen years, who is echoed by many of the other articulate, savvy communications and business professionals featured in this book, "It's a mutual respect. When that does happen, the rest can come easily."

■ ■ ■

I am indebted to the executive committee of the American Institute of Graphic Arts (AIGA), New York chapter, who in May 1987 invited me to develop and chair a Design Management seminar, "Marketing Design Services from the Client Perspective," on which six of these chapters and the concept for this book are based. I am also indebted to the designers across the United States who "lent" me their clients, and thus made this book possible. The dialogues in this book took place in a series of telephone interviews during 1988. They are spontaneous, candid, and unrehearsed. They are truly privileged conversations.

Ellen Shapiro
New York, January 1989

Part One

Introductions and Approaches

Jonas Klein is a visual communications consultant and writer specializing in graphic design and institutional identity systems and management. Before moving to the Maine coast, he spent thirty years with the International Business Machines Corporation (IBM) in communications and design management positions, serving most recently as corporate manager of graphic design operations. In that position, Mr. Klein was responsible for IBM's worldwide graphic design programs including identity, graphic standards, trademark and logotype practice, and coordination of external consultancies. He earned a B.A. in political science from Bates College and an M.S. in social science from the Maxwell School of Citizenship and Public Affairs at Syracuse University. Mr. Klein has served the AIGA as lecturer, judge, and program consultant, and has taught and advised on communications and design topics for many years.

International Business Machines Corporation is a multinational company whose operations are primarily in the field of information handling systems, equipment, and services to solve complex problems of business, government, science, space exploration, defense, education, medicine, and other areas of human activity. IBM's products include information processing products, communications systems, work stations, typewriters, and related supplies and services. Most products are sold or leased through IBM's worldwide marketing organizations. Selected products are marketed and distributed through authorized dealers and remarketers. Headquartered in Armonk, New York, the company employs 390,000 people in more than 130 countries, and its worldwide gross income in 1988 was $59.7 billion, while net earnings were $5.5 billion.

Paul Rand has been a design consultant to IBM for over thirty years. Based in Weston, Connecticut, Mr. Rand is a Professor Emeritus of Graphic Design at Yale University School of Art. His work for corporations, including the American Broadcasting Company, Cummins Engine, Westinghouse, and IBM, has been much-honored. The author of several books, most recently *Paul Rand, a Designer's Art,* he was elected to the New York Art Directors Club Hall of Fame in 1971 and won the AIGA Gold Medal in 1984. Hundreds of designers have contributed to the IBM design program. Also featured in this chapter are **Bruce Blackburn,** former president of the AIGA and a principal of the New York City corporate identity consulting firm Anspach Grossman Portugal Inc.; **Neuhart Donges Neuhart Designers Inc.,** specialists in three-dimensional and exhibition design based in El Segundo, California; and **Pauline DiBlasi,** an independent New York practitioner specializing in advertising and graphic design for museums and galleries.

1

The Importance of First Impressions

IBM

Design
Program

Jonas Klein

Q *Thomas J. Watson, Jr., chief executive officer of IBM from 1956 to 1971, is frequently quoted as saying, "Good design is good business." Can you describe the overall benefit of good design for IBM?*

A Watson was referring to every image a company presents to its wide variety of publics. At the time he made that comment, IBM was clearly in the lead in the computer business, but was facing tough competition and formidable governmental challenges. So it was terrifically important for IBM to maintain a positive face to all kinds of publics.

Watson discovered early on that design could be a great influence in accomplishing that. By 1956, he was convinced that the appearance—and I don't mean that in the shallow sense—the appearance of everything a company produced and every mention of a company's persona should be businesslike, positive, and directed toward serving a customer's need. And that applied to everything from the way IBM salesmen presented themselves to the architecture of the buildings. There was a natural carry-through to all the design processes, especially product design. Eliot Noyes and Paul Rand provided the conduit for this.

Watson was also convinced that design had a positive effect on the bottom line, although he never said, "Let's go out, guys, and make functionally attractive products because design really means big bucks." But that was inherent in everything that was done. Good design was not only good business in the dollar sense, it also was good for the corporation's image in relation to other public categories, such as the activities of various governments: buying, approving, and legislating. And it was true for IBM all around the world. IBM discovered very early in the game that the positive effects on governments and institutions translated into the bottom line, into how IBM was treated as a company, and into how its plants and facilities were accepted as neighbors in various communities. The design program is tied to the company's philosophy of being a positive corporate citizen; everything IBM does should enhance the quality of life . . . and design certainly is an aspect of that.

IBM was selected by the AIGA to be the first recipient of its Design Leadership Award, and has been cited as the first corporation to have a unified corporate identity program.

IBM is one of the largest companies with a design program, but it was not the first. In fact, Olivetti was the catalyst for Watson. Watson was prompted by what Olivetti had accomplished in terms of integrated identity, product, architecture, and advertising. I also think one would have to say that Container Corporation preceded IBM in initiating a corporate design program.

But IBM worked hard at it. Most importantly, the success of the design program and the success of the company were integrated . . . and one fed off the other.

◄ The IBM Design Program press kit folder, designed in 1984 by Paul Rand. Rand was recruited by industrial designer Eliot Noyes, who also enlisted film maker and exhibition designer Charles Eames to carry forth IBM's commitment to good design.

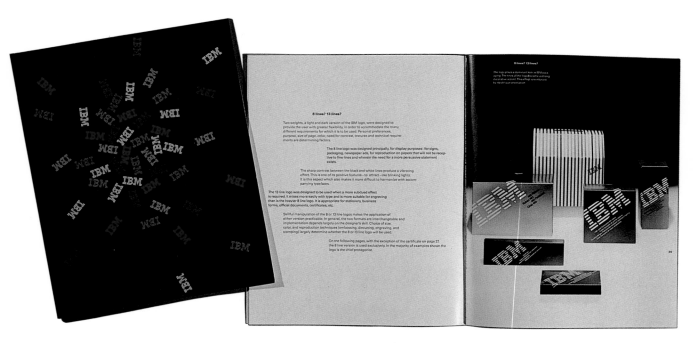

IBM Corporation

The design program could have been terrific, but if the company had been down the tubes, it would not have made a difference, nobody would have remembered. But here was the world's most successful corporation, and it had an integrated design program. So, in people's minds, the design program must have had something to do with that success. On the other hand, the success continued to feed the design program, because the company was profitable enough to attend to things other than merely buying and selling.

IBM has been responsible for a significant amount of noteworthy design work: the design of the equipment itself, the packaging, the architecture, the signage, the promotional materials, and the advertising. Tell me about your role.

I was responsible for corporate identity. That included signage, publications, packaging, and exhibitions. I worked with designers ranging from the largest companies to individual artists and illustrators. Even though people fully realized that we had an integrated corporate identity system, it did not stop Landor or Lippincott or Siegel & Gale or Anspach—just to name some of the large companies that specialize in corporate identity—from calling and coming to see me and offering services.

And you saw all of them?

Yes. I tended to meet with more people than I needed to. It's important not just for a person in my position, but to a corporation as a whole, to see everybody who is interested in offering services; to find suppliers whose skills you don't have or that are superior to the ones you are currently using. I think it is also a responsibility of a company concerned about its image to make itself, as best it can, available to the professional public.

What position did this philosophy of good corporate citizenship put you in vis-à-vis designers who were calling and trying to sell services?

A busy one. Just as an example, in my last three years at IBM, I received over seven hundred phone calls from designers; seven hundred that I counted and remembered.

Can you suggest what designers who are trying to approach any large company might do to turn a cold call into a warm prospect. First of all, how can someone find out whom to contact?

Sometimes with great difficulty. But it's probably easier with a company as large as IBM, with information operators who can answer questions—if the question is framed in a way they can understand. If one were to call IBM and ask, "Who is responsible for graphic design or publications?" the call would probably get through to the right person fairly quickly. But if the caller used design jargon or buzzwords, it might be more difficult. Operators and secretaries understand functional names and descriptions or titles, but not design vernacular.

"The IBM Logo, Its Use in Company Identification" (left), written and designed in 1982 by Paul Rand, opens by stating, "The value of a logotype, which is a company's signature, cannot be overestimated." The spread illustrates the preferred use of the logo on IBM packaging.

Paul Rand designed the outline and solid versions of the IBM logo in 1956; he added the 8-line and 13-line versions in 1962 and redrew them in 1982. They are specified when darker or lighter values are required.

Do you think it helps to send a letter first?

Very often I was approached by letter or another kind of communication in the mail. But frankly, so much mail came across my desk that it was impossible to do much with it. And even if I saw something interesting, it was difficult to find the time to follow up. So I preferred to get a telephone call first. And on the basis of that call, the person and I could talk about what needed to be done so that further communication could take place.

You were really available to talk to people on the phone?

I'm certainly not holding IBM up as a paragon, but most of us traditionally answered our own telephones. And I'm talking about most senior executives.

Does the call have to be from a principal of the firm or could it be from a marketing person?

The call can come from anybody who knows what they're talking about, who is honest, and who represents their firm well. I would say fully a third or more of the calls I got were from marketing people or from principals who were not designers. That's fine, because good marketing people can often provide the same kind of information. Later on in the process, when portfolios were reviewed or we got into detail about capability, I required communication with the designer or creative director.

How much information should be conveyed in that initial call, and what kind of information?

Probably not a great deal of information in the first call, but it should be quite specific. Clearly identify who you are and the company you represent. Explain if it's your firm or if you are a marketing rep, perhaps something about your background and the kind of work you or your firm does. In most cases, when you are approaching any client, that person is not interested in buying everything. So it is most helpful if you determine those things a particular client will be interested in. In my position, for example, I was not responsible for print advertising. My interest was in publications and corporate and promotional collateral. As quickly as you can get to the heart of things, the conversation can take a track that is on mutual ground, and you can develop some basis for the next step . . . which is usually sending a package of samples of your work.

And when you're describing your firm, a prospect would certainly also be interested in the size of the staff, that is, the number of designers. It matters less how many people you have doing administrative work or marketing, but it matters more how many people are really creating work. Most clients are probably not especially interested in hearing that you have a Forox camera or other such equipment. But if, for example, the client is in the computer business and you're doing something with desktop publishing or other advanced techniques, mention that, too, because it says something about your interest in the state of the art, in utilizing the tools that are available.

How well do you think someone calling a corporation should know that company's situation?

When someone called me and asked, "Mr. Klein, what business is IBM in?" I didn't take that too much farther! No one expects you to know the profit-and-loss or the bottom line or the company's organizational problems. But you ought to have a pretty good idea of the kind of business it is—whether it's a manufacturing company or a service firm—and also some idea of its

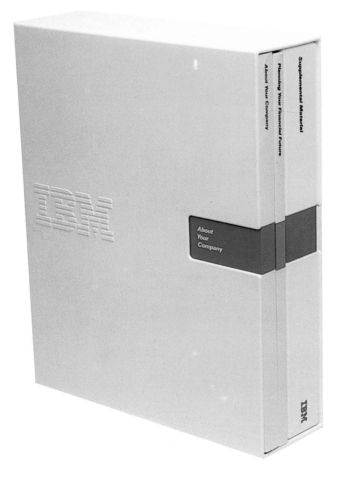

Bruce Blackburn has worked with IBM since 1977, primarily on human resources projects. "About Your Company" (left), a benefits package he designed, has been distributed to over 250,000 domestic employees. IBM approached Mr. Blackburn when the work of his firm at the time, Danne & Blackburn, came to the company's attention through exposure in design journals.

Health and safety in the potentially hazardous workplace are the concerns of the Blackburn-designed "Ergonomics Handbook" (right). A general reference document, it sets standards for subjects such as optimal keyboard height for computer work stations. Illustrations by Jim Silks and Randall Lieu follow the idiom in ergonomics established by Henry Dreyfuss Associates.

Chairs

Backrests are adjustable up/down, backward/forward for good lumbar support

Seat pan and backrests are upholstered and covered in perspiration-absorbent material

Seat pan is adjustable and should transfer user's weight through buttocks, not thighs. Seat should adjust to the user, not vice-versa.

Fully and easily adjustable from the seated position

Telephone/Calculator

Position of same numeral is different, leading to inefficiency, increased error and frustration.

Platform Height

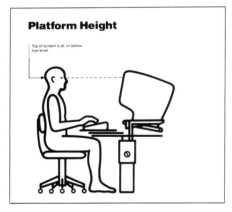

Top of screen is at, or below, eye level.

Lifting and Twisting

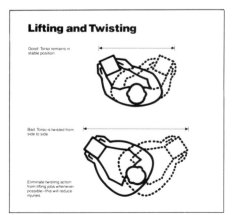

Good: Torso remains in stable position

Bad: Torso is twisted from side to side

Eliminate twisting action from lifting jobs whenever possible—this will reduce injuries.

corporate character. That can be quickly determined if the company is a prominent advertiser. The reason I say that—and I hope I don't offend—but as much as I admire the Pushpin style, just as an example, there's not likely to be a significant opportunity for that style, no matter how well it's done, for IBM. It's just not consistent with the company's needs and corporate style. So if that's your particular style, don't call a company that's Helvetica flush left, rag right, and expect that you're going to get a particularly warm reception.

I'm also thinking about the headlines. For example, did you react favorably to calls in response to news items about IBM? A call that presented a possible solution to a potential investor relations problem or employee relations problem? Perhaps a new publication or promotional concept?

Everybody appreciates an informed call. Last year, there was an announcement of a new contractual relationship between a software company and IBM. It was kind of a unique working relationship for IBM. An enterprising young man with a very fine firm called and said, "I read this in the paper and I was wondering if there might be some special kind of identity problem? Something that perhaps we could provide?" This was a person who knew full well that Paul Rand handles IBM's identity activities in the traditional sense. But since this was a nontraditional event, it presented an opportunity. But just talking about a news story might not be enough to generate interest. You really have to relate it to your capability.

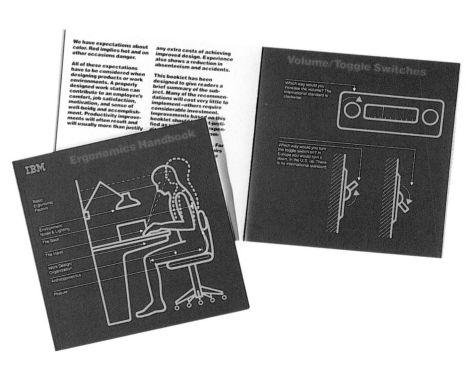

What, specifically, should the follow-up package contain? For example, how important is a design firm's capabilities brochure to you? Did you tend to award the more significant projects to the design firms with the more impressive or comprehensive promotional pieces?

I'll answer the last question first and say no, but I'll back up to it in a minute. During the initial call (and everything I say is in the context of the company I represented, a very large company with a fairly grooved swing, so I can be specific about the things I looked for) I said, "Please don't send advertising because I'm not responsible for it." And I said, "Please don't send annual reports, since you're not going to be competing for IBM's annual report, at least at this time." There are some handsome and well-done reports, but they're not my personal preference as an indicator of the kind of design capabilities I looked for. Another thing I didn't want were slides. I've spent a good deal of my life producing slides and working within the medium, but I don't find slides an effective medium for an accurate demonstration of printed material.

What I did like to see in the package were a few examples of general capability—product or corporate promotion work and editorial communications—pieces the designer felt strongly were the top quality samples of his or her work. That's number one. Number two, I looked for examples of specific capability, things the designer deduced from our conversation I was especially interested in. It's a waste of a potential client's time to look at projects you've done for someone else that don't hit home.

Which brings me back to the question of the capabilities brochure. I know many designers use them. And many of them are very well done. But they don't move me a great deal. They tend to demonstrate what I call womb-to-tomb coverage. They are, by definition, very general. And again, they may miss the target. Capabilities brochures are also reproductions, at least two generations removed from the original pieces. And in that respect they're not as good. If your mailer has a loose-leaf or folder format so you can select individual sheets, so much the better. But the selections had better be your proudest products, because if you hang them out as your best work, well, that's how you'll be judged.

You're saying the opposite of what some consultants are recommending to designers. You don't think designers ought to invest in comprehensive capabilities packages or slide presentations to represent themselves well; good printed samples are more effective.

In my case, that was so. Consultants do not buy services. Clients buy services. Consultants can be very helpful in organizing thoughts and providing information. But if they haven't been clients, their value is diminished. My suggestion, generally speaking, is that designers should have available a number of good printed samples of quality work so they can spread them around to potential clients. And I would advise spending more money on that and less on capabilities brochures.

Should a designer call again to follow up the package and make an appointment, or would that be an annoyance?

They should follow up. I actually invited that. My suggestion is to send the package, fairly specific on the things a client may want to see. Then allow a couple of weeks to make sure he or she gets a chance to look at it. What I did in most cases was literally open a good old-fashioned 8½″ × 11″ file. I had files on over three hundred design companies. Many clients find it difficult to remember everybody and identify their work, but have no problem keeping five or six decent things in the file. Part of the problem is size, which is a whole other story. Sometimes the key is just fitting into a file.

Then, when you follow up, you've had a telephone conversation; you've communicated by mail. At this point, the prospect knows your name, knows some of the things you do, and may be in a good position to work out a mutually satisfactory date to meet and have a portfolio review.

Paintings and Drawings from
The Phillips Collection

IBM Gallery of Science and Art
Madison Avenue at 56th Street, New York / December 9, 1983–January 21, 1984

Pauline DiBlasi, one of the seven hundred designers who telephoned Jonas Klein during his last three years at IBM, engaged Mr. Klein's interest by describing her work for museums and galleries. The result: a series of DiBlasi-designed posters for the IBM Gallery of Science and Art.

Speaking of "knowing your name," did stories about designers in the general or trade press ever impress you?

Favorable publicity is always a plus. But in my case—and I would hope for most companies—I don't think it really made any difference. If you were an honest-to-goodness quality person with a quality service to sell—and you presented yourself and your product in a businesslike way—it didn't make any difference if I had heard of you before or not.

Can you summarize the key things you looked for?

First of all, I wasn't looking for anything! I mean, they were looking for IBM. My advice, though, is to present a capability, not only of your skills, but of your intellect and intuitive powers. And to present as quickly and neatly as you can—if not the promise, at least the hope—that you can solve a business communications problem. You need to be candid and responsive. You need to ask the right questions. You need to listen to the answers. And, I think, respect needs to develop. And that's a mutual respect. When it does happen, the rest can come easily.

A few moments ago you said, "Don't call a company that's Helvetica flush left, rag right if you're the Pushpin style." How much direction did you give designers in terms of IBM's established corporate identity; how strict are the guidelines?

With me, it certainly varied with the project. If it was a corporate identity project, the guidelines were fairly tight, and all kinds of materials were provided. But if the project was less structured, and the design company had demonstrated that they could do a variety of things—some of which fell into the general IBM idiom—then the guidelines were kind of slim. It was my preference—and that of several other people within IBM who have bought design for years—not to specify all that tightly to creative people. There are some designers who do exactly what you tell them. If we needed a simple four-page folder that wasn't going to require a lot of inventiveness, then there was a whole list of people we could call. But if we were looking for some inspiration and thought, and had chosen people who could do interesting and positive things and wouldn't go off half-cocked, then there wasn't that much direction. We'd be defeating the purpose.

If you look at the entire range of materials IBM has produced over the years, you might see some things that will raise your eyebrows, because not everything is exactly Helvetica flush left, rag right. Lots of things are not, and creative people are needed for that. ■

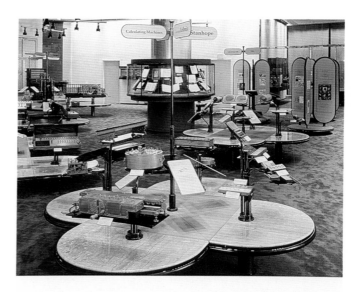

A Calculator Chronicle
300 Years of Counting and Reckoning Tools

"A Calculator Chronicle," an 1983 exhibition that traced the mechanization of arithmetic from the seventeenth century to the beginning of the computer age, was researched, written, and produced by Neuhart Donges Neuhart Designers. Firm principals John Neuhart and Richard Donges, veterans of the Eames Office, had assisted Charles Eames on ground-breaking films and exhibitions for IBM.

Rolf Fehlbaum, president and co-owner of Vitra International, is a furniture producer, design editor, and chair collector. He earned a Ph.D. at the University of Basel, Switzerland. Before joining the furniture industry, he worked in the areas of documentary film, architectural education, and art editing.

Vitra International is a Swiss manufacturer and distributor of office furniture. In 1985 Vitra became the European licensee of Herman Miller for the designs of George Nelson and of Charles and Ray Eames. In the late sixties, Vitra started its own product development with the Panton plastic chair. In the seventies, a number of state-of-the-art ergonomic chairs followed. Since 1979, Vitra has been working with Mario Bellini to redefine the office interior. While producing for the office contract market is its main business, for its experimental Vitra Editions, the company also works with designers such as Arad, Deganello, Kuramata, Mendini, Pesce, and Sottsass. Vitra is chronicling the development of furniture since the beginning of the industrial era; its collection of about five hundred pieces will be presented in a new museum building in Basel designed by Frank Gehry.

2

Making Sure the Affinities are Right

April Greiman, educated in the United States and Europe, is a designer whose work in the seventies and early eighties helped define the West Coast New Wave style in graphics, architecture, and interiors. Her breakthrough work for clients, which include Esprit, Xerox, Vitra, and the Los Angeles Olympics, has received honors in every major show; her works hang in the collections of the Library of Congress, the Smithsonian Institute, and the Museum of Modern Art. Her studio, April Greiman, Inc., employs computer-aided technology in many aspects of its work. Ms. Greiman, currently president of AIGA/Los Angeles, sees herself as creating a bridge between art, design, and current technology, and is developing a new textural language called "hybrid imagery." Computers have also been instrumental in the new patterns she has developed for textiles, wallcoverings, tiles, and other household items.

The Spirit of
The New Office

The Individual matters as well as the Corporation:
there will be greater choice in style, environment and arrangement of the workplace for ordinary office users.

Der Einzelne ist genau so wichtig wie das Unternehmen:
Auch der einfache Büromensch wird Stil, Einteilung und Umgebung seines Arbeitsplatzes wählen können.

L'individu est aussi important que l'entreprise:
Il y aura un plus grand choix de style, d'environnement et de confort dans l'espace de travail pour les employés en général.

L'esprit créative compte le plus:
Les offices seront conçu pour stimuler les idées. Et non pour ranger l'administration.

Das Büro ist ein Computer:
Nichts wird das Design das nächsten Jahrunderts mehr herausfordern als die Bedienung der elektronischen Arbeitsstation.

Le bureau est l'ordinateur:
Le plus grand challenge de design sera la relation humaine avec les stations de travail électroniques.

The office is the computer:
servicing the electronic workstation will be the greatest design challenge.

Software is the key to change:
the management of office space and amenities will have as much impact on the quality
of working life as the physical fabric of the office.

Software ist der Schlüssel zur Veränderung:
Raumgrösse, Komfort und ihre Zuordnung werden für die Qualität des Arbeitslebens
die gleiche Bedeutung haben wie die Art des Bürobaus.

Le logiciel est la clef du changement:
Le traitement de l'espace travail et son confort vont influencer la qualité de la vie professionnelle comme
la structure de l'entreprise le fera.

Neun bis Fünf stirbt aus:
Der Arbeitstag wird ausgedehnt und variiert. Jeder wird mehr Freiheit haben,

um dann und dort zu arbeiten, wo er es will.

the office day will extend but also become more varied.
Everyone will have far greater freedom to work where they like, when they like.

Le neuf à cinq est mort:
La journée de travail va s'étendre et s'individualiser.
Chacun sera plus libre de travailler là où il veut et quand il veut.

Rolf Fehlbaum

◄A page from "Workspirit," the 24-page, trilingual
tabloid, Vitra Design Journal, designed in 1988
by April Greiman and Mike Ellison of
April Greiman, Inc.

Vitra International

Q *The May 1988 issue of* Progressive Architecture *features an article on Vitra that asks, "Can a big furniture company benefit from avant-garde design?" The articles focuses on the furniture itself. Can you answer that question in terms of graphic design? How can your company benefit from avant-garde design?*

A I'm not even sure I like the term "avant-garde" in that context. I am looking for authentic expressions of what is going on, and not for avant-garde per se. If our design is considered avant-garde by some, it's their problem. It is in the spirit of the time. If we do a brochure with April Greiman, it is not intended to be avant-garde; it is trying to find an expression of today. She is someone who can understand and contribute to finding that expression.

Did you interview or consider the work of other designers before choosing April Greiman?

Consider, of course; interview, no. The process I try to follow is to always look at things that are going on, focus on someone with whom I feel an affinity, and then find out whether it is mutual. I do not take the position that the client is the boss. Rather, I think the designer has to accept the client in the same way that the client has to accept the designer. They have to be mutually proud of working together and for each other. So mine is never an attitude of looking at several designers and asking them to show me what they can do; but rather, I will see somebody and say, "I would like to work with this person; I hope that this person would like to work with me, and on the projects and programs we're doing."

Much more typical is a competitive bidding situation in which several firms are asked to submit proposals.

Yes, of course. But that is not at all how we approach things. The really good people are very different from each other, so you will not find the same kind of work by comparing different people. I think you make your choice by having certain criteria and then finding the person who fits your criteria best.

There aren't that many choices in the end. The same thing goes for product design. When we work with Mario Bellini, we don't ask ten people first if we could look at their files or if they could make a prestudy. You focus on the person you think is right, and you hope it works. Most of the time it does because that person feels that you put a lot of yourself into the project, too.

April Greiman's Macintosh-generated explorations (left) for the journal's nameplate. Ms. Greiman's textural computer language, "hybrid imagery," allows her to juxtapose pattern with typography.

The selected nameplate (right). The delicate accuracy of the grid pattern would be difficult to attain with traditional drafting and hand-lettering techniques.

The article in *Progressive Architecture* describes us as a "big furniture company." We are really not big compared to some of the giants in our industry, and furniture companies are small compared to the giants of industry in general. So ours is a very special situation in which the owner/manager conceives of the company's identity, and then looks for a corresponding partner in the design of a product or in communication. This is very different from a large corporation, where there are committees and very complicated procedures.

With us, it's easy. If I like it, it's done. If I don't, it's not. Maybe this is why some of the more interesting things in design come from smaller clients—because somebody in charge says, "I like it." You just have to feel that it's right and have the confidence to do it, which is more difficult in a company where you are directed to

meet certain objectives and have to be responsible to many people and prove it is right. I don't have to prove anything to anybody.

When you find the person who fits your criteria, do you just call up and say, "Let's get together"?

Yes. Then I'll want to meet at their office to get a certain feeling of how they live and work. In April's case, we did not meet at her office because we were in Europe and she was consulting in Europe at the time. But, if possible, it would be nice to see the office.

Did you consider European designers for these projects? I'm impressed that you are willing to work with someone six thousand miles away.

The cover of "Workspirit" combines the elements of a typical publication cover—nameplate, visuals, table of contents—in a startling new way. The central image is a digitized photograph of a toy robot from Rolf Fehlbaum's collection.

A double-page spread (right) explains that "a decisive line in office design will help each individual to share the way of his company." It suggests that Vitra product lines can support the prevalent corporate cultures of our time.

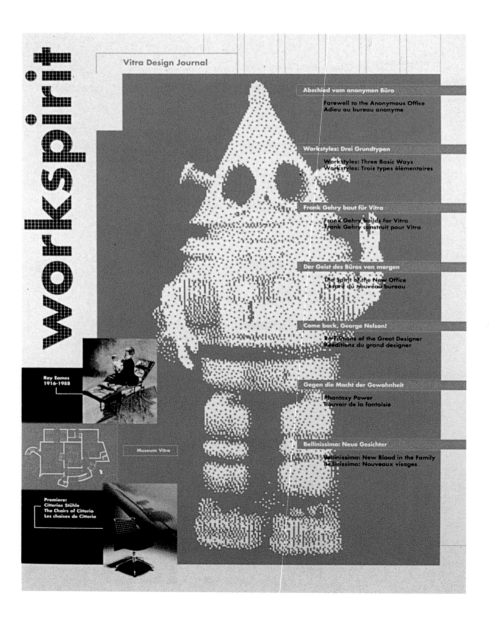

There is a difference doing business with someone in another continent. You tend to be clearer and more concentrated in the brief time you meet. You have a feeling of preciousness of time when you're together. In my case, with somebody in Zurich or Basel, when we have problems we'll say, "Okay, we'll talk about it next time." Next time may be only two weeks away. Halfway around the world is a different thing. In our case, we've just proved that it works.

In architecture, for example, we have worked with Frank Gehry, and it was simpler in a way, because the object was really in the end very much Frank Gehry's product. But in printed communication, the designer needs a lot of information from you all the time about the product and how it works. Providing all these details can be more difficult. But because you tend to think in principles, prepare better for meetings, and concentrate better, the relationship can be very successful.

The article we've been speaking about was headlined "The Risk Factor." It goes on to say, "Big manufacturers are increasingly cautious about producing anything that isn't a sure bet, so why is Vitra International taking the risk now?" Do you feel that there is an element of risk in the work you're doing?

Not really. When Charlie Parker made his music, he didn't think, "I'm doing something risky." It was just the way he heard music, and he felt it. I don't ask myself, "Is this a risky thing? Is it daring?" It is just the way one feels things; it is just the way one sees the world. You know if you do a certain chair, out of the mainstream, a thousand people are not going to order it the next day. You do those special things for a number of reasons. It's a balanced business in the end.

What did you talk about in your first meeting with April?

The first meeting didn't take place because April didn't show up!

I think the only purpose of such a meeting is to check the attitudes, the affinities, not to talk about the project. Of course you want to see if the person is interested in doing the project, and not just in the purely business sense. You also hope that there will be some personal intensity. I try not to have a bossy attitude, but to create an atmosphere where each one wants to find

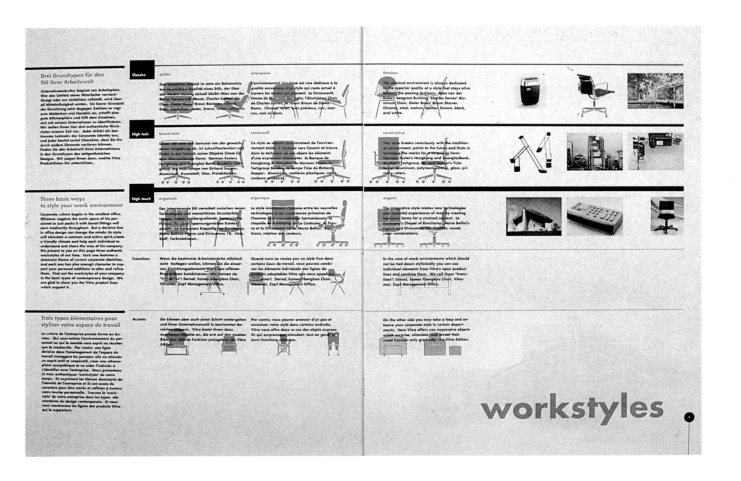

workstyles

1

Development of an editorial spread: April Greiman begins at the computer (1, 2) by blocking out layout elements as form and texture. Using dummy copy (3), she selects type sizes and weights from the Futura family. Kraft paper and two ink colors are specified. Once the composition is fully determined, the text, by German writer Hans Puttnies, is positioned (4).

2

3

out more about the other. Also, I don't look at these relationships as doing a project, but as a long-term investment of time for both myself and the designer.

I think it is just as important for the client to present himself well as it is for the designer. I believe a great deal in that kind of symmetry in the relationship. The client has to be as well prepared, and has to present his company and its goals in a real and positive light. I often feel that there's great arrogance on the client's side, especially with well-known companies, and I think that is ridiculous.

Recently, a close associate of mine presented a group of letterhead designs to a well-known New York architect. The architect, I'm told, swept into the room and dismissed everything with a brush of his hand, saying, "I don't like these. This is an impressive presentation, but I want . . ." and went on to describe something entirely different. He had never taken the time to learn about the design firm, or to state his objectives.

Some clients have that kind of attitude, and that's unfortunate. It's very unproductive, also. A good client gets good work and a bad client gets bad work. If the designer is basically good, he will always do better work for the better client. But think of all the bad designers. Where would they be without bad clients?

How do you set up the parameters of your projects? You are choosing someone to create, for lack of a better phrase, an original work of art for you and your company. How specific will you be with the direction?

I never say how to do it! If I knew that, I would do it myself. When I try to be specific—and I'm not always as specific as I should be—I say why I'm doing it and for what. April needs and wants the kind of restraints that come from a task. I think in design it is very good to have restraints; they help you structure the problem. One wants to define the problem very well so that the designer can work within the specified restraints.

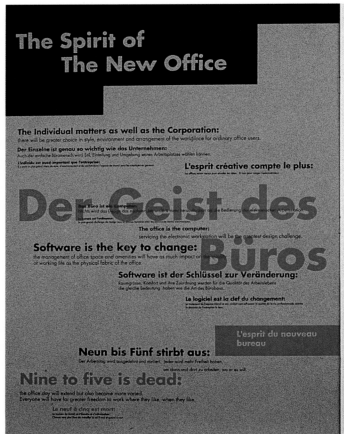

Rolf Fehlbaum

Last year, when April spoke in New York, I asked her, "Your work seems to transcend the boundaries between fine art and so-called commercial art. If you could be successful producing limited edition prints, would you choose to do that?" She answered no, she wanted clients to inspire her work.

That's what I try to do. Sometimes a designer's answer isn't quite right or maybe I don't like aspects of it—then I can discuss why. When I can explain certain things, the designer will usually say, "I understand better now and will change that." I rarely have the kind of situation that some clients encounter, when a designer stubbornly tries to hold onto certain things while the client tries to destroy the designer's original idea. This, I think, is ridiculous. Misunderstandings happen because there are different criteria on the side of the designer and on the side of the client. In which case, the client didn't do a good job of defining the problem—or finding a designer—because the designer he found doesn't have the affinities.

Is it helpful for you to get a proposal that defines the criteria in writing?

If you define the problem clearly, what else could the designer add in writing? What would that do exactly? Hopefully one understands the problem. Maybe there are methods I am unaware of that check whether the designer really understands the problem. Maybe if it were an ad campaign, it would make sense to define the criteria in writing because that is more of a marketing task. But usually words are unnecessary. Designers are there to give words shape and form, and usually they are not that good with the written word.

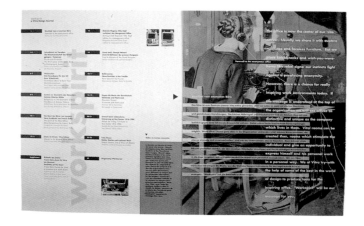

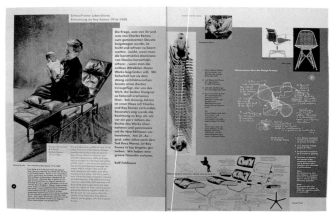

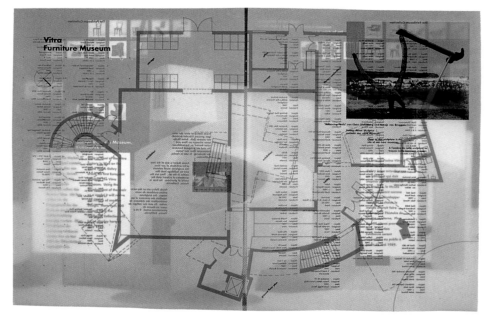

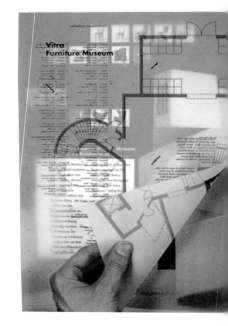

What about a budget or projected costs in writing?

Yes, absolutely, of course. I think it's very important to be very clear on the material side of the relationship, otherwise one tends to be disappointed.

How do you foresee the results of the projects you are doing with April—for yourself and your company?

One hopes that on all levels of your activities, you reach a result that, in the end, will give an integral expression of your attitude. We don't believe in a fixed company style, but the expectation is that you will find in our communication a reflection of our basic values. Since we don't have a product that we can sell to everybody, the relationship of a company like ours to our customers is one of mutual affinities.

You also want to express your own joy. I personally enjoy our products very much and I enjoy what April creates for us—they give me great personal satisfaction. That is another important part of it; the

enthusiasm for one's work. You also hope to pass along that expression of what you're trying to do to related fields. It's not very clear, I'm afraid.

Actually I think it is. You are describing the rapport you have with April. This sounds almost too simple: You want your clients—who I assume are collectors, interior designers, and architects who specify furniture—to sense that and to have the same feelings toward your company's communications. They will be attracted to it, it will appeal to them, and therefore they will be more likely to buy your furniture.

Correct. There are many other intangible levels beyond just the cash register ringing, but first you establish the right customer relationships. In other words, you want the cash register to ring, but you also want to like the sound of that ring. ∎

"Workspirit" demands that the reader learn new ways of absorbing information. Whether the subject is "Farewell to the Anonymous Office" (top row, left), "A Tribute to Ray Eames" (center), or Vitra's Bellini Collection (right), the presentation is layered and complex.

The journal's center spread (below), an 8-page vellum gatefold, superimposes the floor plan of Vitra's Furniture Museum in Weil on the Rhine, Switzerland, on a photograph of Frank Gehry's architectural model of the museum building and a display and listing of the Fehlbaum furniture collection.

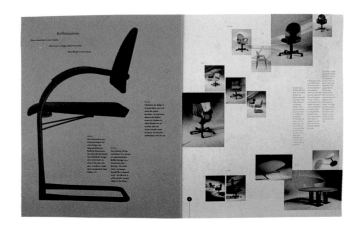

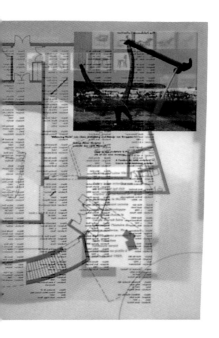

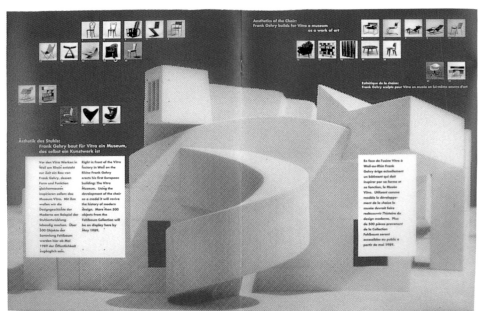

Phyllis Spittler, as vice president of marketing services, directs public and press relations programs and marketing support functions for Century Corporation and many of its subsidiary companies. She previously was director of public relations for 3D/International, one of the world's largest design firms, and managed a full-service public relations agency. She has won numerous awards for her communications programs, including those from the Society for Marketing Professional Services, Texas Public Relations Association, and the Institute of Technical Communicators. A former newspaper reporter who is active in local and state civic organizations and politics, Ms. Spittler was named one of the top public relations specialists in the design industry by *Interiors* magazine and is a frequent speaker on the subject of developing a public relations program.

Century Corporation is a diversified, Houston-based holding company organized in 1973. Its subsidiaries are involved in commercial real estate development, construction, property management, the thrift industry, mortgage banking, and automobile and equipment leasing.

3

Design's Best and Brightest: How to Find Them

Chris Hill is owner and creative director of Hill/A Marketing Design Group in Houston, Texas. Formed in 1981, the Hill Group is responsible for a range of projects including annual reports, brochures, packaging, corporate identity, and advertising for clients including Century Corporation, Champion International, Compaq Computer, Dai Nippon, Dentsu, Exxon, Gerald D. Hines Interests, and Tenneco. In addition to many national and international awards, Hill was recently honored at "Intersect," an exhibit of twenty-two international designers in Tokyo, and has been recognized in the Soviet Union for outstanding design. His work is represented in the U.S. Library of Congress, the Nagasaki Museum of Art, the Museum of Modern Art in Munich, and in numerous private collections.

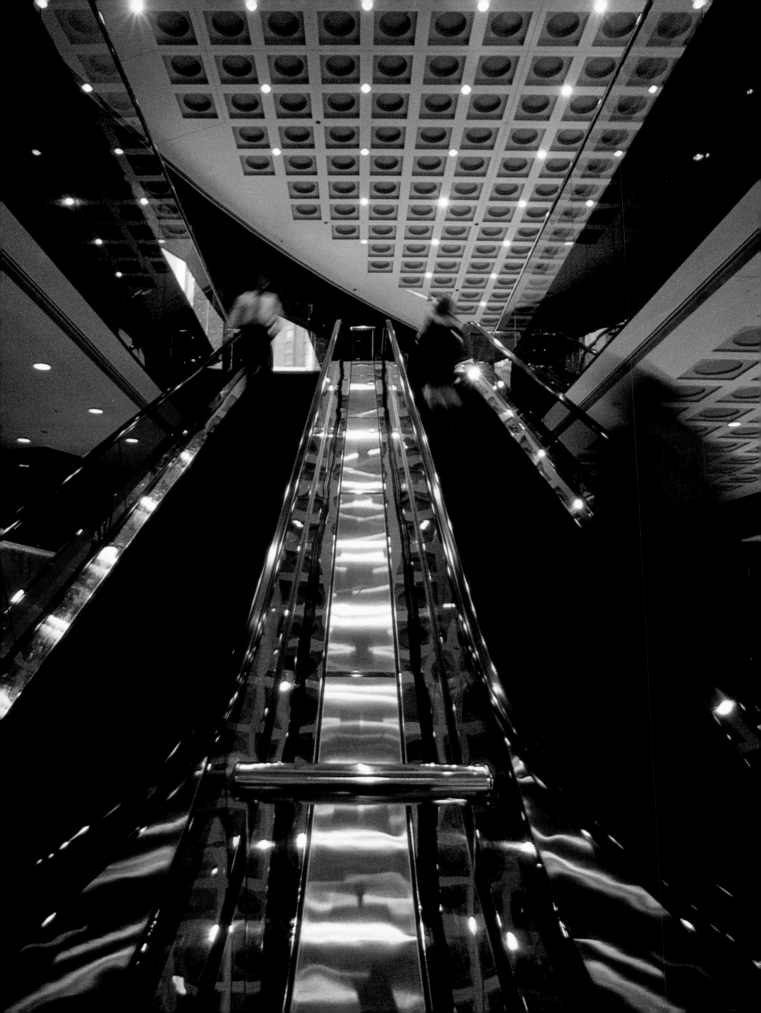

Q *In recent years, designers have identified two general types of marketing activities, two basic strategies that get clients and designers introduced to each other. The first is the kind of marketing in which the designer seeks out the client: makes calls, makes an appointment to show a slide presentation, sends a capabilities brochure or a package of samples. The second is the kind of marketing that brings the design firm's work to the client's attention, so that you, the client, will call the designer. For that to happen, the design firm has gained a reputation for a particular type of quality work. This is in part accomplished through stories in magazines, winning design awards, advertising in creative showcases, and speaking at meetings clients attend. I've heard it said that if the client chooses you, you're in a much better position, a position of respect. Can you evaluate these activities and comment on them?*

A I don't go in for the first group, for slides or capabilities brochures. While slides are a good communications medium, I'm a tactile, touchy-feely person. I like to hold things, to feel the essence of them. As for capabilities brochures, when they come my way—especially four-color brochures—my first thought is "Wow, that's neat, but how much money did it cost to print this big thing? How much of my money could it cost?"

You might feel if you became this design firm's client, you'd end up subsidizing their next promotion?

Right. And while everybody has to have a marketing tool, that would indicate to me that they're a high-priced firm.

I have a public relations background, so your second group of choices is, to me, much more effective. For example, when you have a good story to tell, it's pretty easy to get it told. People should overcome their fear of dealing with journalists. A well-written news release or timely phone call to a business writer or an art critic can get your story out there.

Would that story influence you? If you read about a success a designer was able to achieve for another real estate firm, would you call that designer?

Yes. I like favorable stories in the media. They are a third-party endorsement of your work. However, when you go beyond the level of the local papers or the design magazines, public relations can be expensive. If you're trying to get a major public relations or communications program rolling, you can't do it on your own, especially if you want to get in the national business magazines. You're going to need help, good in-house public relations (which most graphics firms can't afford) or a public relations firm. Costs can run quite high, but can be worth it if the public relations firm is a good one and understands your objectives.

◀A high-speed escalator in a building constructed by Partner's Construction, Inc., the second-largest interior construction firm in the United States, a subsidiary of Century Corporation. The photograph, by Jim Simms, appears in a case-bound, 48-page capabilities book produced for Century Corporation in 1985 by Hill/A Marketing Design Group.

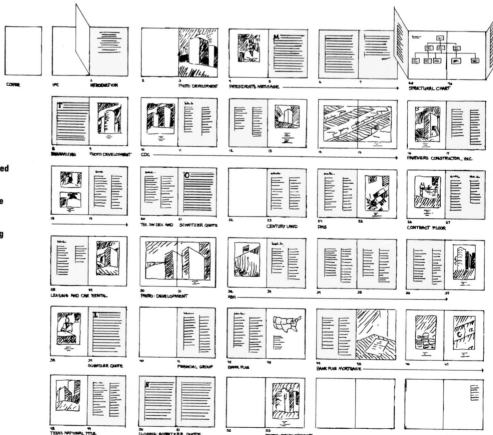

As for winning design awards, I think they make a client feel a little more secure. Secure that they've chosen a designer—or are about to choose one—whose talent has been recognized in the industry. But that, to me, won't sell a job.

Advertising in creative showcases? I don't see them that often, but I grab them when I do. They give me ideas of what's going on in the industry. The publishers should make them more available, perhaps to professional organizations.

Speaking at business meetings where clients might be? That's a real good marketing medium. Those opportunities are few and far between, but every designer should take advantage of them whenever possible.

I'd like to add one more thing, social contacts.

Extremely important.

Everyone's heard gossip that certain plum jobs were awarded because people belonged to the right clubs.

It's the way of American business. And as I said, extremely important. It's a matter of getting your name and your face and your personality known out there. If you're playing golf at the country club, and you know that XYZ CEO is playing, too, if you can get to know that guy, then you stand a leg up on getting into his company. Or if you join a museum organization, your activity there will certainly broaden your range of contacts. Especially if you do good work.

I'm a mayoral appointee to the Clean City Commission, Clean Houston, and at one of our committee meetings, it was announced that a printer in town donated a great deal of printing to one of our campaigns. I came back and told my staff that whenever we

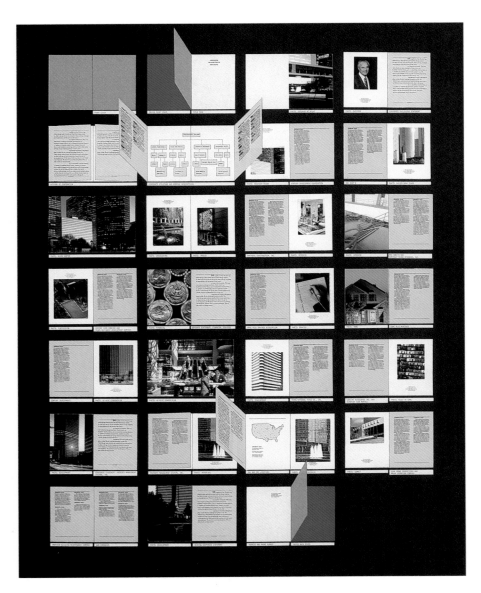

After a series of meetings with Phyllis Spittler, designer Chris Hill mapped out the book's key elements in a thumbnail storyboard (far left). After client approval, the storyboard was refined for presentation to top management. "Scrap" pictures from magazines and brochures indicate photography to be planned, art directed, and shot.